Andy Warhol

Blow Job

Peter Gidal

One Work Series Editor
Mark Lewis

Afterall Books Editors
Charles Esche and Mark Lewis

Managing Editor
Caroline Woodley

Associate Editor
Melissa Gronlund

Picture Research
Gaia Alessi

Copy Editor
Tom Cobbe

One Work is a unique series of books published by Afterall, based at Central Saint Martins College of Art and Design in London. Each book presents a single work of art considered in detail by a single author. The focus of the series is on contemporary art, and its aim is to provoke debate about significant moments in art's recent development.

Over the course of more than one hundred books, important works will be presented in a meticulous and generous manner by writers who believe passionately in the originality and significance of the works about which they have chosen to write. Each book contains a comprehensive and detailed formal description of the work, followed by a critical mapping of the aesthetic and cultural context within which it was made and has gone on to shape. The changing presentation and reception of the work throughout its existence is also discussed, and each writer stakes a claim on the influence 'their' work has on the making and understanding of other works of art.

The books insist that a single contemporary work of art (in all of its different manifestations) can, through a unique and radical aesthetic articulation or invention, affect our understanding of art in general. More than that, these books suggest that a single work of art can literally transform, however modestly, the way we look at and understand the world. In this sense the *One Work* series, while by no means exhaustive, will eventually become a veritable library of works of art that have made a difference.

First published in 2008
by Afterall Books

Afterall,
Central Saint Martins
College of Art and Design,
University of the Arts London,
107—109 Charing Cross Road,
London WC2H ODU
www.afterall.org

ISBN Paperback: 978—1—84638—041—9
ISBN Cloth: 978—1—84638—043—3

Distribution by The MIT Press,
Cambridge, Massachusetts and London
www.mitpress.mit.edu

Art Direction and Typeface Design
A2/SW/HK

Printed and bound by
Die Keure, Belgium

Andy Warhol
Blow Job

Peter Gidal

Writer and film-maker Peter Gidal has previously published *Warhol: Films and Paintings* (Studio Vista/Dutton, 1971 and Da Capo Press, 1991), *Understanding Beckett: Monologue and Gesture* (Macmillan/St Martin's Press, 1986), *Materialist Film* (Routledge, 1989) and *Gerhard Richter: Painting in the Nineties: The Polemics of Paint* (Anthony d'Offay, 1995). An influential experimental filmmaker, Gidal has had retrospectives at the London Film-maker's Co-op; LUX and the National Film Theatre, London and the Centre Pompidou, Paris. He taught advanced film theory at the Royal College of Art, London from 1971 to 1983.

In memory of Gregory Battcock

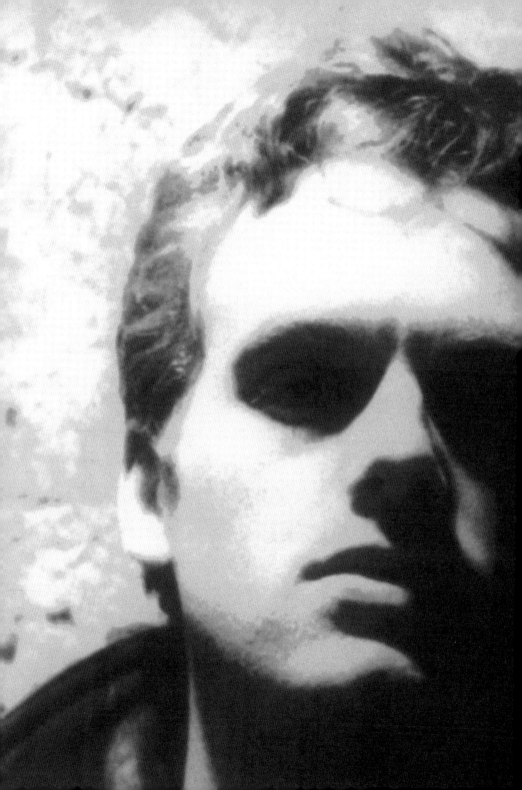

*I never understood why when you died, you didn't
just vanish, and everything could just keep going the
way it was only you wouldn't be there. I always thought
I'd like my tombstone to be blank. No epitaph and no
name. Well, actually, I'd like it to say 'figment'.*[1]
— Andy Warhol

*Little body little block heart beating ash grey only upright.
Little body ash grey locked rigid heart beating face to
endlessness [...] Figment dawn dispeller of figments and
the other called dusk.*[2]
— Samuel Beckett

Being to the Point of Nonbeing
You see a man's full-frame head staring out at you.
He is being looked at by you, the viewer. He is within
a space, against a wall, but we are not sure if it's
inside or outside. We can presume it's the Factory.[3]
Throughout Andy Warhol's 1964 film, with its
deadpan title *Blow Job* (figs.1 — 12), we never see
more than the man's head and shoulders in this
space. As such, the filming of a sexual act is extended
into an exploration of duration, the emptying-out and
finitude of time. The body's physicality is set against
film's materiality, and the processes of knowing
and unknowing by which we understand a work.

The black-and-white film lasts 36 minutes. It is
made up of ten 16mm reels, projected at silent speed
(18 frames per second).[4] Each reel of around 100 feet
starts with an array of effects — fogging (which

The Factory
Black-and-white photograph, 1967
Photograph by the author

occurs when the film is exposed to light before being developed), edge numbers whizzing by and image flare; each ends with flare-out, which is caused by light seeping between the metal reels holding the footage when it was loaded into or taken out of the camera. In most films, light seepage and numbering dots are edited out; Warhol's *Blow Job* is made up of the reels as shot — and in the order, apparently, in which they were shot. It takes at least three or four minutes to take a finished reel out and replace it with a new one, so we can assume that the breaks between each reel are at least that long. After each break or reel change, the action begins again, again and again.

<p style="text-align:center">❁ ❁ ❁</p>

It was in my first year at Brandeis University in February 1965 that I first saw Warhol's *Blow Job*. It was shown to a few dozen people before the weekly art-house film (Antonioni, Vigo, Godard or some early Ealing comedy).[5] The audience was completely quiet. I would not say that this quietness necessarily meant acceptance, but it suggests that they watched the film without attempting public denial. Three years later, it was shown there again, in May 1968, the year of marches to Mississippi and anti-Vietnam war protest, not to mention Paris. But, this time, the film — ostensibly of a man receiving oral sex — clearly made the audience uneasy. Jokes were made out loud; hands were waved in front of the projector bulb.

When I saw *Blow Job* for the first time, I had neither seen nor read about a Warhol film before. Having just come down from four years at high school in the Swiss mountains, I placed the work within a European tradition. The film's *mise-en-scène* of blank grey walls and dull existential alienation created a viewing for me, that first time, with some referential hold, however 'right' or 'wrong' my interpretation was in retrospect. The structure into which it fitted included Hölderlin's poems; Genet's novels and plays; Beckett's figures being out of synch either with themselves or with others, particularly in 1957's *Endgame*; and Giacometti's negative and positive light through clay and bronze.

I recall the critic Gregory Battcock getting very upset when, in a throwaway remark on Warhol's *Liz* lithograph (1964) — which I had just bought for $10 and hung on the wall with Blu Tack — I made a casual comment on Warhol's decadence and camp shallowness.[6] Battcock stridently defended the seriousness and radicality of Warhol's art, in how it took on contemporary culture's representations (in much the same terms as I'm utilising in describing *Blow Job* now).[7] Not that Warhol — the most famous and the most popular artist of the twentieth century — now needs lone voices in the cultural wilderness defending the radical seriousness of his work. However, his courage in being prepared to act without denying his sexuality was no mean thing, then or now.[8] *Blow Job* is still seen as an experimental and difficult work — its engagement

with time and sexuality as difficult now as it
was then; its presence, for the viewer, still as
problematic, as uneasy as it ever was. This is perhaps
best evidenced by the fact that just eleven people
attended the recent National Film Theatre showing
of the film on a weekend afternoon in August
in London — the same number, give or take a few,
as forty years ago.

The Spectator
A film of a man engaged in a private act suggests
a minimum of four agents in the space: the actor,
the man (or woman) servicing (or not) the actor,
the artist filming and the spectator watching.
How can the actor be looking at someone in the
filmic space and at you, here, in another space?
You, the viewer, stare at 'him', that is, at the film-
image of him, while he stares at (and, more often
past) you. Immediately, the set-up of the film
establishes a semi-conscious reflexiveness, with
the viewer foisted into a position of voyeurism.

Is someone being looked at by the subject/object —
i.e. the actor (the subject of the film and the object
of attention) — are *you* being looked at? The regard of
the subject of the film towards the spectator renders
the spectator into a subject as well. The film is a
process, a mechanism, a technological and ideological
process *that includes you and that cannot exclude you.*

You see a man's full-frame head staring out at you.
He is being looked at by you, here and now. But the

question is whether you, the viewer, are being looked at — even within a system that does not, in the same actual historical moment (1964, when *Blow Job* was filmed), include a 'you'. Is the look through the lens at you, the spectator; a general spectator encompassing you, the spectator watching the film; or the one specific spectator behind the camera (that is, Warhol) at the time of filming? Or should we, in fact, understand 'the spectator' as a category, a stand-in or a double? All these terms are misnomers. The so-called spectator in 1964, if he/she existed, is not somehow now symbolised — or his/her place taken — when seeing this film. It is the *position* of the spectator that is important here, which, for the man filmed — the visage that looks past the camera at a 'you', a spectatorial presence — existed then as much as it exists now.[9]

What can be called the condition of spectating is the awareness of being viewed at the same time that one is viewing — which is, in the end, an ideological condition. There is an object, that which is filmed. Yet the protagonist — the man seen — is, of course, at the same time also the subject of the film, so we can call him the subject/object. And the question as to who, what, where, when and how does a subject become an object, and to what degree does it carry ideological implications of objecthood — i.e. fetishisation, reification, etc. — is important for the definition of the object, both in concept and in concrete reality.

The man in the film frame is looking out at a viewer. The conventional cinema tool of the eye-line match means that the actor's eyes are looking at yours, and yours at his. Throughout this 36-minute film, however, the man in the film frame looks mostly not at you; mostly, the stare is the stare past, while you, whether male or female, are looking at him. (Whether you are a 'he' or a 'she' becomes paramount, as well as irrelevant, in *Blow Job*.) The actor is being pleasured by a he or she (the former an assumption, but no more). Every few moments, there is a shift from near-passive awaiting into a less passive anticipation of the pleasure that is *seeming to be beginning* (as Gertrude Stein might have said) or is being beginning — the state of being of beginning. When this happens, a shift occurs that lets some of the detritus of one's daily life lose validity and immediate import. The body takes over through pleasure.

The viewer can see the person viewed shifting positions, first in passively awaiting pleasuring, then in his seeming to shed the self-consciousness that keeps his world and consciousness itself controlled. There is a willing, or an allowing, of uncontrol, that initially identifies *what* is being seen and done and then identifies *with* the sexual possibilities of that sensation — such as, for example, our not being held to gender.

The imaginary space that is inhabited, the space within which the sex act itself is presumably taking

place, is no less real for its not being seen. It's there and not there, here and not here. Warhol, in the act of materialisation — i.e. the *making* of this film — as much as with the *projection* of this film, strikes the real and the imaginary together. The real world is appropriated by the film, and this physical appropriation collides and becomes one with the cinematic means of production. It is the disinterring of the one from the other that makes for the impetus and libidinal energy of this film.

Recognition and Pseudo-Documentary

There are certain films that are always about film, that are about the way in which cinematic representation presents images-through-time, via the camera, the lens, the film stock and the maker's hands and eyes. In such films, consciousness is at stake. The filmic cannot represent consciousness. These films attack recognition — as representation that *allows* recognition denies a work its materialities, its processes. In *Blow Job*, the flare-ins and flare-outs seen on the film do not document what is absent — importantly, they are not a document *of* anything. They are material presence and process made visible on screen.

The attack on recognition is linked to my notion developed in the early 1970s of the 'pseudo-documentary'. However different-seeming and experimental a work might be, if it allows, for example, representation of the male and female body or if it contains figurative or recognisable

elements, then it is really a pseudo-documentary about precisely the naturalism/realism it purports to be against. The result is one form of compositional formalism or another in the end, the artwork becoming a mirror of the maker (yet again) or of this style or that, where the viewer/spectator *only* knows truth, beauty and history through recognition. However, problematising representation and recognition is key to the film movements of Structuralism and Materialism, in which the material processes include the viewer viewing his or her subjectivity — no less than that which the camera is aimed at — rather than a denial of that presence.

Some minutes into the viewing of *Blow Job*, we may begin to tentatively imagine how this film was being made — is there, for instance, someone off-screen saying 'Do this,' or 'Do that'? There are stories about Warhol leaving the room whilst filming continued. Warhol, in fact, rarely did this, and when he did, it was with specific circumstances in mind; it was not a general work ethic — though it has been fetishised as his way of working by those with an adamant refusal to take the work at face value, i.e. seriously, and also by those who produce this myth as some defensive antagonism in the face of art's threat.

Warhol leaving the space was an imagined way of working, one somehow perfectly documented and 'proven' by a film such as *Blow Job* that obviously makes no reference to Warhol — either his presence

or absence. Artworks always run the risk of becoming, for some, the pretexts to confirm what they already 'know' to be true. The attempt in this book, however, is to not let *Blow Job* become a pretext for what is already known, seen or recognised. For if film is not a Materialist process, but becomes just a pretext, then there is no need for it.

A question of substitution becomes relevant here because, as a subcategory of metaphor, the substitution of one thing for another always means an image for a word, a word for a thought, a thought for a feeling and so on — such that the real substance of what's being shown on film is overtaken by what it 'stands for' or 'represents'. If the film becomes a substitute for a sex act, then it is something other than a film. *Blow Job* does not fall into this trap — its reel changes disallow editing's condensation of time to build artificially towards some resolution; they allow it to be a film, and not a stand-in for something else. The endless trip-ups and re-beginnings of the film takes do not preclude orgasm, but do preclude any seamless narrative identification by the viewer, who unconsciously colludes with a quasi-pornographic scene. There are moments, fragments and endlessness. There is no narrative totality, no dramatic totality. There is a subject/object, the man standing there being fellated (a word that doesn't transmit the pleasure of the act in the slightest). The concentration on that becomes its own distantiation, since it can't be erased (a conscious mechanism) or repressed (an unconscious one) in its

durable and unendurable duration. The act's
re-presentation, what you see, exists at the same
time as the presentation, the presence of duration
and the inscription on material film.

In Warhol's films, fragments of acts — things
seen or represented — are obliterated by unendurable
durations; whereas in non-Warholian cinema,
unendurable durations — time's material passage
through film, film's temporalities — are obliterated
by narrative enactments (however fragmentary).
What this means is that no matter what the 'sense
of time' is in a film sequence you are watching,
the enactment of an act — say a kiss or a killing
in a Sam Fuller film — (melo)dramatically demands
that you, the viewer, identify with the person(s) in
the enactment, kissed or killed. Or, at the very least,
such a scene demands that you identify with the act,
if not with a person. The identification with that
narrative act, the suspension of disbelief, 'going
with the action', means that time — the presence
of time's passage, that material physical presence —
has to be obliterated for action to proceed. You can't
be 'involved' in an act or action and simultaneously
be distant, outside of it, present only to the passage
of time. Time *takes* time. If time is allowed for the
viewer's viewing, then — to say this in a condensed
form here — all the back and forth acts that are
going on in the scene have to be either marginalised
or repressed or forgotten or somehow made not to be
the focus of attention, otherwise one would 'lose' the
sense of time. This is why we are living a paradox

of simultaneously being in time and obliterating it — within film, art, etc., or outside of film, art, etc. Living, thinking and breathing partake of the condition of illusion, and, in order to proceed with life, time's existence — the running out and down of time, duration, death — is necessarily obliterated. By this, I mean that what is necessarily obliterated is *identification with anything outside of that, at that moment, for that time*. The condition of art and the condition of life become, paradoxically, the 'same' on that level — what Brecht called 'realism, but realism of another kind'.[10]

Here in *Blow Job*, the conditions are never given for the viewing to become an imaginary scene, as in a theatrical production or Hollywood film (however imaginary the sex act could be). This is where the question of Materialism comes into play. Materialist practice in avant-garde film is often misunderstood as a dry academic thesis about material, whereas, in fact, it engineers a dialectical, contradictory and endlessly fractious relation with the subject-as-viewer, and with his or her philosophical, sexual and poetic metaphysics. And it is precisely in this fraught relation that a Materialist process inveigles itself.

A Materialist viewing doesn't mean sitting back, with you in your seat and the film on the screen for however long. It means the inability for you here (in your present) to even begin to securely be a 'you', or an 'I' or gendered. The same goes for the 'it' seen

there on the screen (in its nevertheless reproduced semblance).[11] The collision of uncertainties makes *Blow Job* a film *of* process: not one that represents or produces an illusion of process, or *about* a process, but one *of* process directly — as film moves through a projector and runs out. The Materialist process of the film disallows the meaning, the use, the ideology and the engagement of a work residing in description — as if meaning were to reside in saying, for example, 'Then, there are two reels of imagery of a garage, then one reel of a man in a hard hat in a mortuary wandering around, then a shot of a juggler for five seconds slowed down, then back to a zoom shot of a corner of a room in the dark.' The intervening question of time, in its passage from him (then) to you (now) — and the philosophical implications as to the *meaning* of such time and notions of duration — will be dealt with later.

This viewing, as the film is a fact of 36 minutes — through, with and against time's superficies — inculcates against any mechanistic follow-on from moment to moment, from the last and to the next, or any logic that could be preordained, then fulfilled, then finalised. On the contrary, each moment becomes a difficulty, in terms of not knowing with any immediacy what there is to see, what is being done, where the subject even is and whether that unknowable subject is him or you.

The subject-viewer within the film-as-projected means a fugitive subject.[12] I am referring to both

him and you as fugitive, no matter how much
he (the subject/object there in the film) can be
recognised or can be reproduced in this book, etc.,
and no matter how much you as viewer exist, take
a coat off, sit in the cinema in a chair and get up
and leave when it is over. With some art, there exists
a disjunction between what we know to be the real
— i.e. 'I will meet you in an hour at home' — and
the limits of language.[13] Hardly a sentence goes by
that does not merit interrogation, hardly an image
goes by that does not merit interrogation, *unless*
the decision was taken to suppress precisely that.
Which is why so often for life to proceed, it's a
matter of measures not being taken. It is not that
so many images and words are clear and transparent
and not open to the need for impossible and endless
interrogation. It is rather that an arbitrary ideologi-
cal decision is made to curtail such, in the interest
of getting things done.

Interrogation might be the wrong word, so what
is the right one? 'Questioning' leaves the term too
open to its not mattering what the results are, as
a formalism, a liberalism that begs more questions
than not, similar to 'agnostic' versus 'atheistic':
to think we don't know, to know we don't know,
and to think we know we don't know. 'Questioning'
would be analogous (if there is such a thing) to
thinking we might know.

Proust's *À la recherche du temps perdu* (variously
translated as *In Search of Lost Time* and *Remembrance*

of Things Past; 1913–27) is not about time regained but time lost. 'In search of ...' means not that you find it but that you don't. In a similar manner, Warhol's *Blow Job* refuses to let the viewer produce with it a viewing that coalesces questions and answers in the interest of satisfactorily coming to an end. Let alone coming.

Tableau
Male homoerotic chiaroscuro — representations of the male body, representations of one kind of beauty or so-called beauty — is never far (seemingly) from *Blow Job*'s imagery. In 1964, Warhol made *Harlot* — ostensibly, an examination of glamour and celebrity worship, but, in fact, a film about self-consciousness (see overleaf). Seated on and kneeling behind a couch and staring impassively at the camera, *Harlot*'s four stars form a tableau, as of a painting or film still. Mario Montez, dressed as Jean Harlow, spends most of the film eating bananas; at one point, he dispassionately kisses Gerard Malanga, Warhol's assistant. Carol Koshinskie holds a white cat (which has a life of its own and, as such, is a disorganising principle); Philip Fagan, Warhol's one-time boyfriend, kneels behind the couch. The camera, too, maintains a fixed position — despite the fact that at this stage of Warhol's film-making, he often used zooms and pans. As the four pose, three off-screen voices comment on the action: they supplement the action, extending its plane into the off-screen, invisible space.

A process is made via (and through) representational attempts, and this cannot exclude that which is viewed. In *Harlot*, this means that we get not 'just' a tableau but a series of movements, from the tableau on-screen, to its sound off-screen, to the point of view 'shot' — however invisible — in the direction Philip Fagan is looking out at from the couch. This mechanism of using off-screen space persists in many of Warhol's films, including *Blow Job*. At the same time, the structure is reminiscent of the nineteenth-century art historian Heinrich Wölfflin's descriptions of Italian art of the fifteenth century, as much as of Duchamp's sexually ironised absurd metaphysics and physics or of the weight of a body, the weight of a sound, the movement of coming and going, etc.[14] In *Harlot*, the off-screen sound is not synchronised — i.e. not coterminous with any 'there' from which, at one point, an off-screen voice would emanate. From an angle off-screen (top right), one hears Warhol's voice, whereas Philip Fagan (the poet in the film) looks with deep black eyes to another point, centre-right of where he sits on the couch. Cat, women, men, shadows, hands, bodies: touching. Almost. Almost?[15] The examination of the material process of the film is one that looks at more than a film's physical material; it includes the 16mm acetate as much as the pressure of hand, the eye and the mind. The off-screen voice, for example, is a disembodied voice — not at one with the off-screen implied invisible presence.

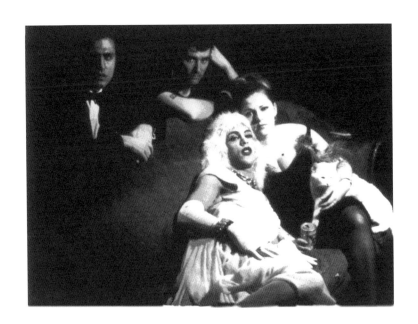

Still from *Harlot*,
16mm black-and-white film,
sound, 66 mins, 1964
© 2008 The Andy Warhol Museum,
Pittsburgh, PA, a museum of
Carnegie Institute

Invisible presence is no less real; it is a concept —
and a reality. The illusion of reality produces a real
suspension of disbelief. This is akin to the way
in which 16mm film's black leader operates as a
stand-in, in some avant-garde films, for edited-out,
'missing' times and spaces. As such, the black leader
does not signify blankness or arbitrary structure;
rather, it's part of a matrix that demands a stand-in
for something missing — the illusion of representing
a narrative *as if it were reality*. In a similar way, the
use of black leader often does not betray the illusion
of narrative film but, rather, reinforces it. So, in
an experimental film, the use of black leader for
ten seconds can imply that something of that length
is 'missing', yet a scene, however invisible, can be
felt to exist there, rather than the black film strip
(which, for ten seconds, is being just that — ten
seconds of black projected onto the screen). It would
thus become a stand-in — the concept of invisible
presence — for something perceived as existing
elsewhere, existing only in its absence. So it func-
tions as no less 'real' than something you can see
and hear whilst viewing. It extends the illusionist
space to the off-screen, the voice behind the camera,
the unseen spaces. If there's a look outwards in
the direction of off-screen sound, the viewer/
listener is immediately placed specifically at *that*
moment. Film as moment-to-moment is thus neither
some after-the-fact analysis nor an opportune
(opportunist) synthesis of sound and meaning etc.;
it is neither literary nor literal, but a material
process in time — film as projected.

For the past fifteen years, Callie Angell, as curator for the Andy Warhol Film Project at the Whitney Museum of American Art, New York, has been researching each segment of each Warhol film — looking at both the filmic and the biographical. It is from her work that we now know that in *Harlot*, Warhol was there in the off-screen space, adjacent to (or in front of) the recorded scene, speaking, making decisions: 'Move that hand a few inches to the left, the light a bit higher, at more of an angle, so the shadow behind reaches over further on the back of the couch ... cover part of the hand resting near Fagan's shoulder while the white cat is let loose to jump off his leg to roam around the couch base and run off-screen then reappear and ...'[16]

Velázquez's painting *Luncheon* (aka *Three Men at a Table*; c.1617, see overleaf) enacts a disturbing, not-unrelated recognition and subsequent process of unrecognition that *Blow Job* instigates time and again. Faced with the painting, one stares at the black figure behind the three people at the table, staring in order to make out the gesture — or grimace or horrified look — on the face in the background. Within about five seconds of standing in front of the picture, giving up, trying again, not managing to make it out, the face, on the figure backed to the wall, looks horribly twisted, deformed, wrenched into distortion. Five more seconds of staring at the horrific face — then realisation: it is not a face, but a hat on a hanger. A sleeve below makes it look

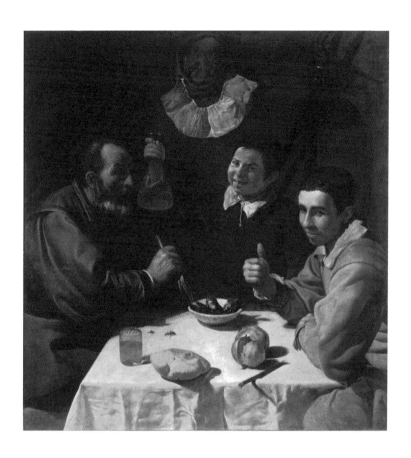

Diego Velázquez
Luncheon or *Three Men at a Table*
Oil on canvas, 108.5 × 102cm,
c.1617
© 2008 The State Hermitage
Museum, St Petersburg

as if there is a standing body: the distorted hat it's 'head', a collar on the same hook it's 'shoulders' — so the darkness below is not a body at all and the face not a face but the top view of a crumpled wide-brimmed hat, a blank oval top that hangs impressed on a hook or nail in the wall. Now that no visage is visible, the configuration is emptied of recognition, or rather filled with the fearfulness of the deformed face (a description which is itself a problem, in its implicit assumption of a norm of rightness) — frightening grimaces folded into themselves remain, whilst we realise that Velázquez used his dark, rich colour at the apparent figure's waist height so that the arm of the boy, sitting at the table, could possibly belong to the body behind that is actually not a body at all. Just darkness; disappearance into fearful, anxious, dark death. The painting's insistent morbidity is heightened by a shaft of light coming from the left-hand foreground, which hovers just barely before receding into dark. Death is present — not as metaphor or allegory, nor as something narrative or able to be put into a narrative, but the blankness of death itself, if death be this falling, staring, thinking into the grotesque fearful distortion, unbodying of a contorted *in extremis* face.

The off-screen 'look' in *Harlot*, as described previously, was not coterminous with sound. Warhol speaks (barely audibly) from one point, while, two moments later, Fagan looks away from the direction of the sound. In *Blow Job*, this circuit is the same without the sound, i.e. it is not a silent film, but

one with absent sound. As in the Velázquez, this non-congruence is a deformation of time and space, a structural deformation — a chasm or an abyss. The making 'nothing' materially present alternates with those moments where there is no such presence-in-absence, just absence — nothing but the relentlessness of the temporal, which is death. Simultaneously, the endless stillnesses of the surrounding darkness — both in the diegetic space (encapsulated by the film frame) and in the cinema space (within which we are situated) — produce receding chasms of space.

Harlot can easily be diagrammatised — its perceptually visible forms split into the form given by Marcel Duchamp's *La Mariée mise à nu par ses célibataires, même* (*The Bride Stripped Bare by Her Bachelors, Even*, aka *The Large Glass*; 1915–23, see opposite), with its composition of:

1. The coffee grinder (one of the mechanistic shapes in the lower, 'bachelor' panel)
2. The glass (the 'canvas')
3. The broken glass (the texture)
4. The stoppages' funnel-like descending shapes
5. The *through-the-glass* fourth wall, a glass wall.

Horizontal and vertical subdivisions of squares result in a focal point of an unseen spiral, whose centre is the point of the golden mean. Duchamp used *The Large Glass* to put forward an allegory of violence and desire into which the viewer could visually

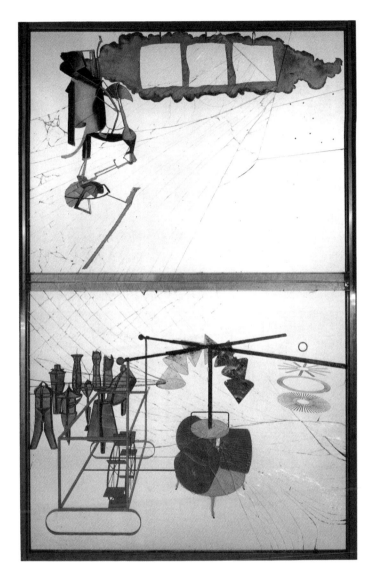

Marcel Duchamp
The Bride Stripped Bare by Her
Bachelors, Even (The Large Glass)
Oil, lead, dust and varnish on glass,
277.5 × 175.9cm, 1915—23
© Succession Marcel Duchamp 2008;
ADAGP, Paris and DACS, London

enter, while at the same time forcing the viewer into the position of viewer/voyeur. In that manner, Duchamp didn't manage that crucial Warholian anti-voyeurism which only functions whilst *looking itself* — the act, in time — is problematised, made difficult during engagement. Duchamp either hauled you in or threw you out, which isn't the same thing.

However Warhol's 'fourth wall' is also made of glass — that is to say a mirror. Where *The Large Glass* provides a materially invisible fourth wall, in *Blow Job*, it is both the bourgeois fourth wall — a transparent screen through which we watch proceedings as if it wasn't there — and, at the same time, a mirror, in which the man's every move induces the self's mirror-recognition, *not looking out at all but looking in, to (or, at least, at) himself*. A space made for the subject to mirror himself, through his endless repositionings, re-lookings, re-mirrorings; that being the circuit he is within.

In reference to the theatrical uses of the notion of the fourth wall, Beckett's mode of theatre directing was anything but fourth-wall realism — his own German production of his 1952 work *Waiting for Godot* (*Warten auf Godot*, Schiller-Theater, Berlin, 1975), with its tableau of marionette-like movement and 'speaking' style enacted a play that was anti-narrative and anti-illusionist and which forestalled identification; the playwright's *mise-en-scène* disables at each moment any possibility of a naturalistic viewing. Yet for his 1957 play *Endgame*,

again in his own German production (*Endspiel*, Schiller-Theater, Berlin, 1967), Beckett utilised opposite means to produce the variegated effects of distantiation: namely '*Spiele es genau als sei da eine vierte Wand, als sei eine vierte Wand da.*' (Play it exactly as if there were a fourth wall there.) There we have classic realist theatre pointed to opposite ends. The result? An unhinging of means and ends. No less can it be said of Warhol's *Blow Job* or *Harlot, Henry Geldzahler* (1964), *Kitchen* (1965), *Lupe* (1965), etc.

Death/Loss (Again)

Remember that *Blow Job* is projected at silent speed, 18 frames per second (or on some projectors 16 fps), though it is shot at 24 or 25 fps (depending on the 16mm camera used). The film's movements and the subject's movements are therefore slowed down by one-third from the recorded speed to the projected speed; you are adding one-third, or six frames per second of viewing. That slightly distended feel when the actor moves his face, when his eyes avert their look from diagonally downwards to straight at you and past you, is as if the image is catching up with itself, or lagging — what was called 'drugtime' or 'dragtime' (in the spring 1966 issue of *Film Culture*). We now know this notion of slowed-down time as having meanings given by the concept 'Warhol film' or 'Warholian' — a set of meanings that are, by now, pre-given and not newly made by each experience of viewing. They are meanings agglomerated, partaking of spontaneous viewings whilst part of the culturally

given surround. The cultural and culturally known becomes, for the spectator, inseparable from the particular experience, as are the various knowledges and beliefs about Warhol, Warholism, Warhol's time — what you bring to the viewing pre-digested, the whole lot. As Beckett would have it, 'we'll make sense of it we'll put it in the pot with the rest / it all boils down to blood of lamb'.[17]

There is a momentary disjunction in *Blow Job* when the actor's head falls far back and his chin, at a 45-degree angle, is momentarily inapprehensible or, in any case, not satisfactorily apprehensible.[18] It is a fearful image. The fear of death doesn't need more than a moment. Until the head moves down a few frames later — around 18 frames, or one second in silent speed projection — or long enough to recognise once again the visage of one man standing framed by the camera in light and shadow staring out at you. At times, of course, he is staring away from you; at times, he is listening to something off-screen. Without hearing anything, you can tell (by the way he reacts) when some order or instruction is given to him. *Blow Job* is anything but fourth-wall realism, and the seen space includes (mentally, for the viewer) the off-screen space of sound and image, however invisible both may be.

At points in *Blow Job*, a shadow takes over from the recognisable face of the man, in much the same way that the shadow in Warhol's *Liz* silkscreen,

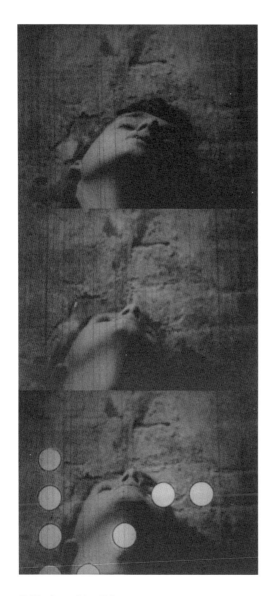

Stills from *Blow Job*,
16mm black-and-white silent film,
36mins at 18fps, 1964
© 2008 The Andy Warhol Museum,
Pittsburgh, PA, a museum of
Carnegie Institute.

for example, or the *Shadows* series of silkscreens (1978; see opposite and overleaf) takes over from the viewer's momentary recognition and perhaps mistaken knowledge of what is represented. The spectator moves from an understanding of the depicted object — that exists as part of the 'real world' — to a state of suspended or arrested recognition, the sense evoked by the shadows of the piece. This obfuscation of the point of origin — i.e. of the supposed *what it is* that it is — occurs as if the *how it is* (the way an artwork is made) could be formally separable from the work's subject. It puts forward the false illusion that the content can be disentangled from the making — either during the viewing or after the fact, during analysis. Failure to disentangle the two derives from the impossibility of taking something in time out of time — rendering something that unfolds as a temporal process into a meaning that exists as the iconic eternal. Warhol's works are emphatically not iconic.

The question of time, the taking up of time, of running down and out of time, forces one to first encounter the question of time's finitude.[19] It can't be a running down and out of time if time is endless, not having any egress or entropy (which means that, in a closed system, matter deteriorates and energy is lost). Therefore, if there is an ideological or religious belief system that incorporates the notion of the running down and out of time, then it would be one that lacked any possibility of fulfilment, in the word's two senses. The first sense would be of time as a possibility within a material world, the

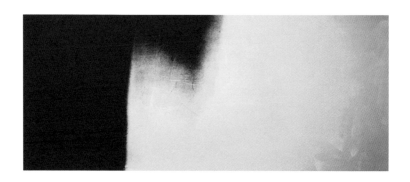

Shadow
Synthetic polymer paint
and silkscreen ink on canvas,
203.2 x 487.7cm, 1978
Courtesy Gagosian Gallery
© 2008 Andy Warhol Foundation
for the Visual Arts, Inc./ARS,
New York & DACS London

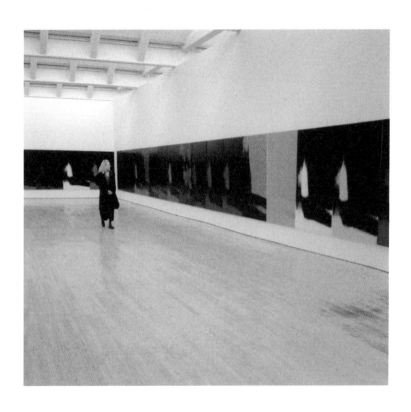

Shadows
Installation at the Dia:Beacon,
New York, 2007
Courtesy Dia Foundation, Beacon, NY
© 2008 Andy Warhol Foundation
for the Visual Arts, Inc./ARS,
New York & DACS London

technical sense of a time-filled period, a time-filled space of life. The second would be of the ideological implications of fulfilment, the conventional usage of the term: happiness, truth, beauty, the rest of it.

If such a universe were to exist, where time was finite and the world not eternal, the viewer would be placed in a position wherein real present time runs down and out. Such a system is very different from one wherein it does not, and the work that constitutes such a system is of itself an attack, at least a discomfort, posed against the viewing (via the filming) of a universe that is slowly diminishing. The anti-evolution of the former, wherein real present time runs down and out for the viewer during his or her experience of viewing (an enactment of entropy), is already a violence done to the imagined continuum that the viewer lives within as unspoken comfort or habitude.

The questioning of that habitude in *Blow Job* is of a structural order — rather than part of the particular represented narrative. Enacted through Warhol's repetitions, it creates in the viewer the disturbance of both a break in assumptions set up by the work itself and the problem of having to deal simultaneously with entropy, egress and temporal endlessness. It is a radical shift of that *a priori* to the specific duration of this film — you, in this time, in this place, and all the specifics thereof, your anticipations, memories, flashbacks and dreams of things. All these are *other*, but necessarily

contingent upon the film's particularities, bringing the real world into the film-viewing process, rather than excluding it. The film itself is not the only real world, just one, at the particular moment of viewing. This all makes for necessities on the viewer's part to somehow situate him/herself in relation to habitude and its disruptions.

Beckett's 'Proustian equation' has Proust's narrator M being terribly disturbed by any change, and then (once accommodated to it) disturbed by any further change, even one reverting back to origin.[20] M leaves his room in Paris for a hotel room in Balbec, where the curtains are a different colour, the ceiling much higher, the place overall very different — then, two days later, M is wrenched with pain at the thought of leaving that space, not for another unknown but to return to his habitual and long-known home. The painfulness of loss this alludes to is the painfulness of loss that is not contingent but present.[21] The viewing process of the Warhol film also evokes a loss of presence — that is, when the image is faded out to a blank light screen — and such a loss induces not just fear, but an awareness of being within such an ongoing process of attrition and entropy. Whilst light is metaphysically not an absence (and the Gnostic and Einsteinian — though not the Eisensteinian — readers must please inhale here and not exhale until the argument is over), from a purely technical point of view, extreme light can create an absence of image. Note the conventional fallacy in respect of the blind (whom we think see

black but who insist they see white). 'Obliteration through light as much as through darkness' was (according to the London Film-maker's Co-op catalogue of 1974) one of the realities, conceptual and concrete, for (as an example) my *Room Film 1973* (1973), as it attempted to make the physical materiality of viewing and the process of viewing inseparable from the idea, i.e. from the meanings made, consciously and unconsciously. One's own practice informs one's ideas and one's theoretical positions *vis-à-vis* other's.

Material Light
An antagonism in *Blow Job* is, for example, between your being looked at by the subject and being avoided by the subject and, through time, a transfer taking place, so that you the viewer *are* the subject and he in *Blow Job* is no longer such but re-becomes the object. This extends to a point where the language in the perceiver's (your) head cannot decipher the line where subject and object are delimited. Such a process is to be defined here not as ambiguous but as a process of the antagonisms between the material and the metaphysical, whether one wants to use the overused term dialectic or not, whether one wants to use the overused term contradictory or not.

Contradictions are produced when watching any film in the split between a certain believability and your imaginings — or between the spaces seen and those alluded to. The split may occur between the phenomena represented for you to see when watching

and the unerring continuum of the projected film's
persistence in your time and space — and the distance
between your 'real' time and space and the time and
space of the filmed reality, and so on. Such a notion
of contradiction is anything but the cliché of the
term, which fantasises an 'opening up' of everything
(in life and in art) from the dread induced by
'closure'. Such an 'opening up' would suggest a world
wherein all meaning is pulverised, where there is
no real, where all is virtual — a convenience for the
interests of some liberal 'choice' mechanism (bound
in the interests of global capitalism, patriarchy
and the mythically free individual). In fact, specific
relations are subsumed to the endless free flow of
either non-contradiction, pure and simple, or a more
'sophisticated' level of an opening up, a freedom,
an ideal, which uses the term contradiction precisely
to obliterate its material reality.

Blow Job manifests a different kind of loss: the
physical material loss of image. This engenders
a loss of the subject/object, a loss of recognition
of image (or 'representation and its holds', in Stephen
Heath's wonderful phrase of 1978), as well as a loss
of aura.[22] Warhol's cinema deals with this directly
in the fadings out of 'being', made via the impossible
magic of cinematic illusion and the notion of being
as that which, with or without aura, is established
through the initial recognition of a person staring
at you, in some social relation to you, made via
the photochemical traces upon a surface of film
that is then projected.

The projection of light itself creates a material realisation — in this case, an image in time — that is separate to the ostensible blow job. The head of a person staring out and past you betrays a series of reactions — as much as (and no less than) Muybridge's sequence photography or Japanese *Bunraku* masques.

Brechtian distantiation techniques emplace a certain amount of objectification, through a series of gestures that fill a monologue or silence or by the viewer's emplacement that is necessitated by film-time's passage. The film produces a viewing and situates the viewer *vis-à-vis* its temporal relentlessness. The temporal is inextricably linked to the process of viewing, and one cannot take place without the other.

A film makes its own habitude, all artworks do, *Blow Job* does so within the first two minutes. Once past the starting fade-in, or flare-in, the film has created its own temporal habitude: the particular way it will deal with time by presenting time's passage on screen. And the loss of that, each time each reel ends, is felt as loss by the viewer. It is no longer the endless temporality of time, passage, death — these are lost when the flare-out at the 'end' ends each reel, that loss remains after the many reels when the film — however long, boring, difficult, endless — ends. We are always left with nothing but loss.[23]

Five or ten minutes into *Blow Job*, the distantiation
is of the viewer viewing a series of gestures, the
subject watching, anticipating, becoming closer
to a psychologically manifested angst (or lack of
it) or excitation (or 'near coming') — only to be
lost by the film running out and the restart being
precisely that, a re-start rather than a continuing
differently, as much as for the camera as for the
subject's sexuality: a restart in the teleology of
coming to orgasm, its abilities and disabilities,
consequent or simultaneous gestures, with one
prefiguring the other in no particular order —
close, far, closer, almost coming, not coming at all.
That panoply of states is expressed here as a series
of *masques*, related to some imagined real scene
— of an attempt to reach climax and the varied
incommensurables.

Yet the viewer is not lost in identification as
voyeur, but precisely the opposite: we are unable to
lose ourselves in the series of acts represented. The
invisible fourth wall functions as an impenetrable
barrier that keeps us on the outside.

It is no use being told that, logically, we don't
know for sure whether he is acting, or that we don't
know for sure what here is real. There is a level of
realism in Warhol — 'realism of another kind' —
that is taken as given, one element of which is the
suspension of disbelief, in order to believe that
this man is having sex. This suspension of disbelief
belies, at one level, the Materialist question. It leaves

us stuck in the miasma of 'Is he acting?' Whereas consideration tells us that he is both acting and having sex. That's the best we can make of the bad lot of representation *qua* representation.

If he is both acting and having sex (and both be believed by the viewer), it is from this perception, initially, that things begin. The momentum of Warhol's film is through repetition of the same scene, beginning again whenever each 100 feet of 16mm film run down and out. The actor, his body, has the same enforced break that the film-change has; time has its material effects on film — and, 'within' the film, on the body. Inasmuch as we can read it, time has its material effects on the psyche of the film-maker as well. A disease as both illness and unease. The machine of film subordinates the body, as a machine-part, to the 100-foot reel of film, through the non-coincidence of the body's time (the actor's real body reaching orgasm) and the camera time (the stoppages to change reels). The subject's glare of indifference is an effect of that, the dictatorial imposition of the filming apparatus. Unlike a loop film with its mechanistic repetition of acts and effects, *Blow Job* stages the sequential re-beginnings of an act.

Mechanistic Repetition
The reprinting of material, technically called its mechanistic repetition, can function in time, as a repetition of the same that takes place 'later'. In that re-viewing, the repetition becomes a memory. Thus

the palimpsest of memory re-viewing a 5-minute film for a second time is different from that of the first viewing. The whole 5-minute film thus functions as a mechanistic 'loop', as the repeat begins the moment the first five minutes have been shown, thus the 5-minute film becomes a 10-minute film consisting of two 5-minute films. This is why even a mechanistic repetition often functions for an audience as a question. 'Is that the same five minutes? Is it five minutes, or much longer, or shorter? Were some cuts missing? Were those the same cuts, the same length for each segment? They seem shorter, the second time round.' The known, re-seen, seems shorter, since it is lacking the anticipation and anxiety of unknowing.

Interfering with any of those possibilities is the immediate perception which questions whether what is seen is the same or not. The questioning position for a viewing is, psychologically, intertwined with (and caused by) the temporal. It takes time to figure it out, to try to see and think from perceptions gleaned from the known, from a recognition of the real. That time taken would, paradoxically for the viewer — within his or her reflexiveness as to time's passage, boredom, anxiousness, waiting, spoiled teleologies and anti-narratives — *speed time up*, whilst it functions (materially, psychologically and simultaneously) as *time obliterated*. This is because the taking up of time, its being filled, is what obliterates it. When there is seemingly nothing there to take time up, that nothing, death, that void,

vacuum, brings time's passage itself to both the material surface of the screen and to the viewer screening the screen, the viewer's time. *That* time's passage becomes, then, the however unconscious subject, and that is always empty, the running down to death in endlessness.

This process proceeds during this example of the same five minutes repeated, five minutes of 'real' time, causing or resulting in the fullness of re-recognition, i.e. during the repeat of a whole 5-minute film. It can be acknowledged as a mechanical repeat, thereby vanquishing the anxiety of the possible unknown re-appearing in the differences of perception. The unknown cannot 're'-appear, as any re-recognition would function then as the known, and the known does not bring with it the temporal anxieties of the empty — time's passage as time — and of death. That is why it is a structural/materialist aesthetic — not just one of structure or Structuralism or of just materiality or Materialism.

The known — what we understand as given, and what is given by illusionistic film for us to recognise — may have other forms of death-riddenness, but not those of the experience of temporality, the material process in its presence. Re-appearance (even of the unknown) becomes the known and is full — full in that it is recognised, however full or empty the particular contents are.

The Ostensible Subject and Sex

The ostensible subject of Warhol's *Blow Job*, in the figurative sense, is the man standing there, the focus upon which is the immanent belief in this subject *qua* object. However, when you see a work like *Blow Job*, evidencing as it does the process by which it has been made, and the 'presentation' of which is simultaneously also the representation, the two become inseparable. Thus the subject of the film is never just what you 'see'. Just as in a Warhol silkscreen, for example, of a car crash or a suicide, the mark of the squeegee that Warhol runs across the silk material of the screen fades to nothing by the time the squeegee has been forced along three feet of canvas. That process *and* its evidence is the image seen as image, of a fading, or a tentativeness, of a suicide figure jumping from a building held in space but surrounded by disappearing imagery due to the process of its own making.

Blow Job — its series of images, its series of events — becomes uncanny; it enforces a viewing, rather than a consummation, and it offers neither identification nor some generalised definition of otherness. Its significations, however delimited or negated or radicalised, are made near-impossible. If impossible, they would vanish. If they can't vanish, the best they can do is make recognition and stabilisation as *unimaginable* as possible, real in that sense, even if termed 'unimaginable' — since unimaginable means that one cannot conjure up a sufficient, satisfying whole in one's head, outside

of the time it takes to perceive. Unimaginable also means that one cannot think something as being timeless and real, outside of the viewer doing the thinking. The 'imaginable', to put it another way, means some ideal, something that exists in spaceless, timeless truth — without a process, without a viewer, forever. The term 'unimaginable' must always be understood against the severe problems that the term 'imaginable' brings with it.

Warhol's work as such existed and exists within such a syndrome. The bland titling (*Blow Job*, *Eat*, *Sleep*, *Empire*, *Henry Geldzahler*, *Harlot*, *Kitchen*, etc.) can seem to encompass, cover, somehow make whole that which is a fragment — not fragment *of* (some whole), but rather fragment *as* fragment. The Warholian titles — empirical, unquestionable — make the operation of the art possible. So, without the title *Blow Job*, the endless interpretations would have to begin; with it, they can end, and one can get on with the film as film.

The man moves his head to the left, the light cuts across his features, and the frame is crossed diagonally as well. Halfway through the film, the actor stares straight at you, catches you in his gaze and, for a moment, you are looked at through the miasma of time and space, history, screening space, lights, flickering projection, sounds in the room and sounds in the projection booth — all of them. He sees you, fixes you, although there is no question of the viewer thinking he or she is being

seen. It is uncanny to be looked at, whilst knowing this is not possible. The space between knowledge and perception in those moments disrupts the seamless proceeding in time suggested by film.

Once the convention for this particular film is established, one falls into a habitude of existing within its codes and verities — which lasts here for around half an hour (unless one leaves). The viewing proceeds within the codifications made by the work for the viewing, placing the viewer and this specific experience within the present, not the represented 'history' of New York in 1964. Within this perception, the sense of being fixed by the eyes of the subject intrudes unexpectedly, the first time. Ten minutes later, when again his glance sweeps yours, it is already placed within the competence of the viewer of the already known, and however disconcerting, with its echoes of the first time, it is not the first time.

The reflection upon such a position — between perception and knowledge — means that reflexivity is a position for the viewer *whilst* the film continues, thus forcing (at the very least) two operations at once: perception is never *not* interfered with, nor is knowledge left untouched. Whenever you apprehend something, your memory of what preceded that percept, your anticipations of what might occur and your subjective response to the way the image presents itself all interfere with the seamless flow of something 'there' to imbibe satisfactorily,

unproblematically. Similarly, knowledge (what you then think you know when you see the actor, his gestures, his looks, his reactions) is always interfered with, as time continues whilst you look and whilst you realise your misapprehension — that what you thought was occurring (or imagined was occurring) is other than what is there. In *Blow Job*, what you think you know about pleasure, about an 'other' and about off-screen and on-screen perceptions becomes constantly re-corrected so that your knowledge is questioned — as is your knowledge of what you know to be truth, what you know to be beauty, what you know to be erotic, what you know to be eroticism linked to homosexuality, what you know to be sexuality linked to heterosexuality. The history of that process becomes the history of viewing in those 36 minutes, the representation changing its meanings in terms of present, past, memory and expectancy. It becomes equally the history of the off-screen space of the act (and the ambiguities it might resolve), in terms of gender, fiction and sexuality. The disease of identification with this imaginary voyeurism is equal to the disease of identification with the act itself.

The eroticisation of the act performed and its immediate, simultaneous de-eroticisation exists in no films besides Warhol's, because only Warhol's work uses a superimposition of sexualities — and this does not refer to any filmic *image-superimposition*, rather a mental superimposition of our notions of gender and ambivalent sexualities.[24] The protagonists in

Warhol's film *Women in Revolt* (1972), for example,
are transvestites, specifically in this film a sexuality
not adhering to some phenomenal perception such
as 'male' or 'female'. Warhol does not resort to the
usual anxious defences that make such sexualities
unthreatening socially, assimilable to the givens
of culture — the film withholds any solid category
of gender. *Blow Job* also refuses to put up the defences
relied upon by commercial narrative film — which
make of everything represented, however seemingly
different at first, something nonetheless digestible
to the comforts of the given culture, however patriar-
chal, racist or sexist they might be. In such a system,
transgression is always against a known, which is
no less powerfully believed and satisfied for being
transgressed, bolstered by reactionary convention-
alisms like *jouissance* that let the bourgeois reader
succumb to fantasies of difference. Always the same
fetish, the same icon, the same familial categories
and the same language for the apprehension of the
'new'. Everyone and everything can remain as before.

Warhol offers an emptying out of belief — in
the veracity of what the viewer sees and thinks he
knows. What seems, when recounted journalistically,
to be Warhol's decadence is anything but, since
it confuses (as he did in his personal and social
persona) the 'so what' with an eager embrace of
anything, everything, whatever the ideology. His
'so what', in the face of works that brought anxiety
and a certain 'death-fear' to dominant cultural
forms, is anything but decadent.[25]

When the actor does not look out at the viewer, or
our assumed group of Warholians helping or standing
around whilst the film was being made, but instead
stares at his own arm, or looks somewhat troubled,
or turns to the left and looks as if at something —
not in response to the blow job, but in response to
nothing apparent — the sexual act becomes dislocated
at those moments. It is no longer automatically
assumed to *be* at all; the actor becomes a body stand-
ing there in headshot simply waiting. Somehow, the
assumption made from the title and the performed
act are separated to the point at which real boredom
sets in, not the boredom of not being able to come or
the boredom of re-beginning the attempt at orgasm
and its inabilities and interruptions but, rather,
the non-attempt at anything, a silent stare, an air
of unconcern. At those moments, the inviolability
of the actor as person takes over as the content of the
film. Communication becomes imagined. At those
assumed moments of just being, there is again a real
invisible fourth wall between you (the viewer) and
him (the viewed), but not the fourth wall of Ibsen's/
Strindberg's theatre, with all its varied attendant
forms of realism, and the catharses supposedly
following from that. An anti-cathartic realism
remains, as this voyeuristic 'seeing' becomes its
opposite: the invisible fourth wall (which should
allow you to encroach on (and into) the scene —
even to the point of identifying what is there and
simultaneously identifying with it) is here the
film screen, shutting you out. In so being shut out,
your reflexivity as viewer functions apperceptively:

you watch yourself watching, knowing the complexities of identification, rather than believing in it and (via catharsis) supposedly expunging or purging fear and pity.

The Aristotelian notion of purgation via catharsis can be critiqued to show how it is withheld by temporal limits and, as such, is never finally successful, once and for all. If you believe that purging yourself of fear, pity, horror, guilt and anger whilst viewing the theatrical — a purging via your identification with certain actions witnessed onstage — there is still the problem of what happens afterwards. You are left with the same self, the event is over and the process has to take place again and again *ad infinitum*. Catharsis is always the *illusion* of catharsis, which allows the horrors to continue. Such notions are overturned by Warhol's radicality in the absolute resistance to identificatory mechanisms, let alone any narrative continuum throughout, as well as by Warhol's absolute resistance to any notion of a catharsis stabilising the viewer as a reified voyeur/subject of consciousness. You don't leave a Warhol film feeling better, and you don't leave it feeling so much worse that you can feel better for feeling worse. You are left bereft; in that, there's a strange parallel with the position of the subject within *Blow Job*, who is also the subject of the film, as well as object — in the same way that the viewer is both subject and object and neither.

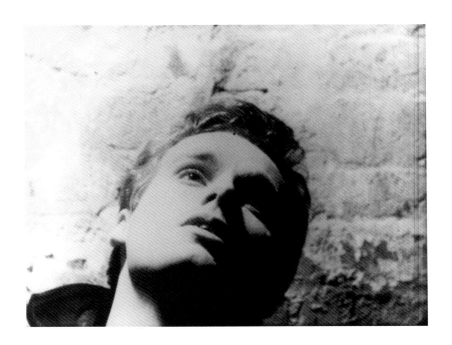

1—12. Stills from *Blow Job*,
16mm black-and-white silent film,
36mins at 18fps, 1964
© 2008 The Andy Warhol Museum,
Pittsburgh, PA, a museum of Carnegie Institute

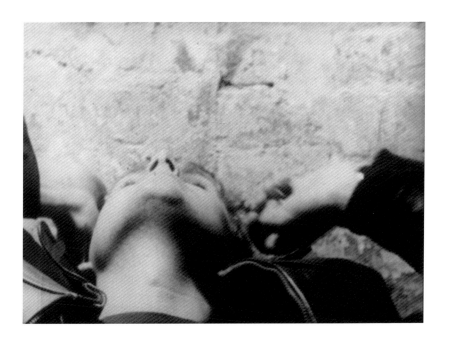

2.

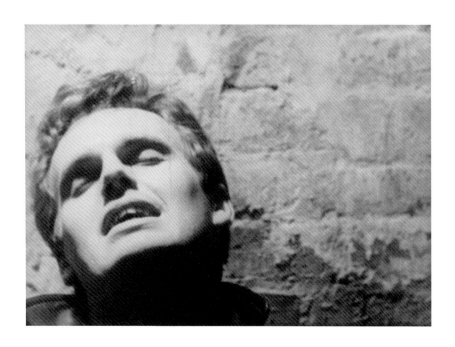

3.

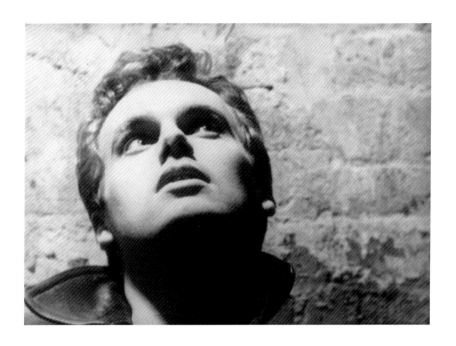

4.

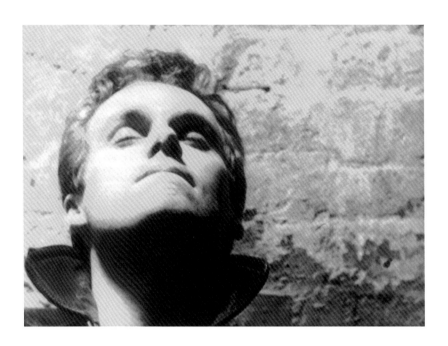

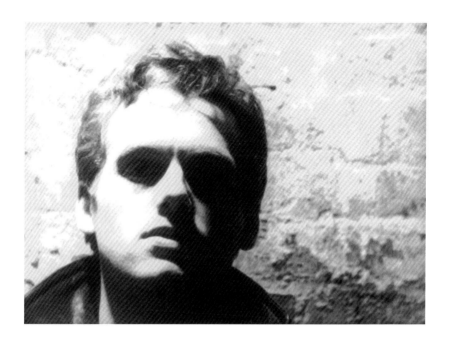

6.

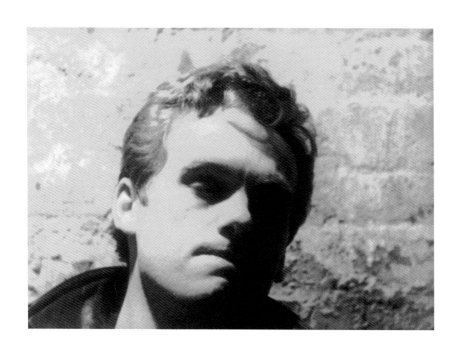

7.

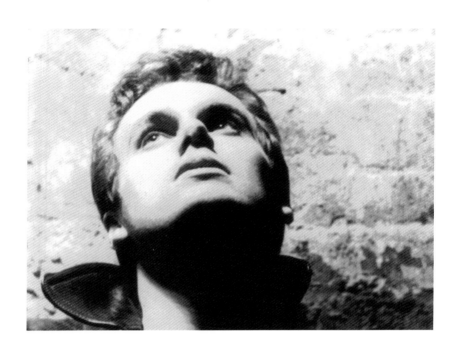

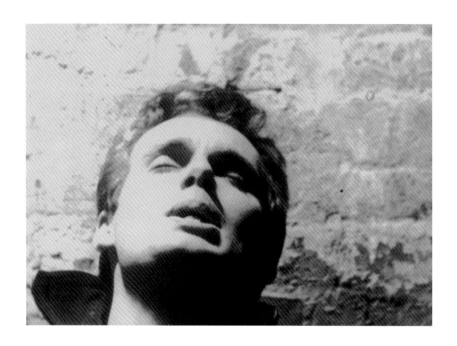

9.

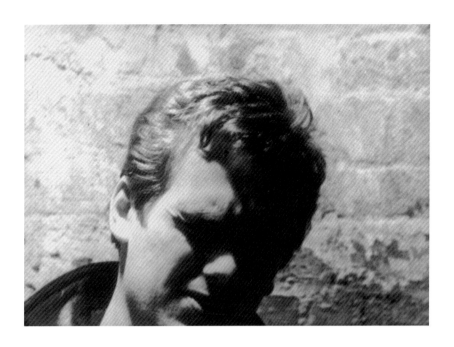

10.

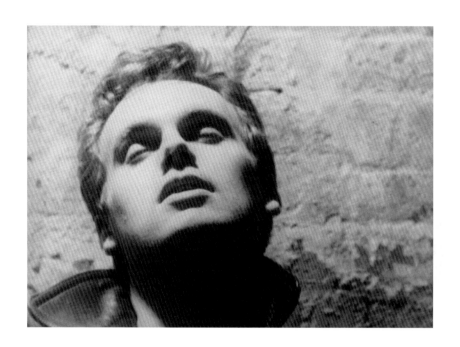

11.

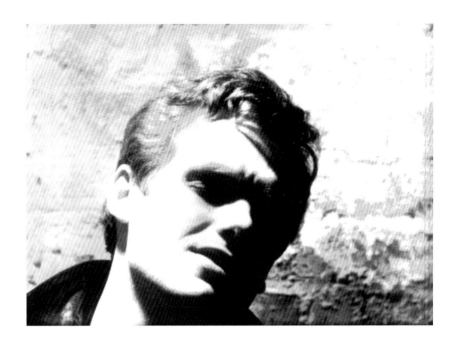

12.

Idealism Etc.

In his analysis of Henri Bergson's philosophy, Bertrand Russell identifies a wonderfully similar confusion of the subject and object, the result of which, Russell argued, makes the material object entirely mental — held in the mind rather than in material reality. His discussion of this problem — which is one enacted through time in *Blow Job* — is pertinent here in relation to the status of the subject/object in the film.

The confusion of subject and object is not peculiar to Bergson, but is common to many idealists and many materialists. Many idealists say that the object is really the subject, and many materialists say that the subject is really the object. They agree in thinking these two statements very different, while yet holding that subject and object are not different. In this respect, we may admit, Bergson has merit for he is as ready impartially to identify subject with object as to identify object with subject. As soon as this identification is rejected, his whole system collapses [...]

The distinction which Bergson has in mind is not, I think, the distinction between the imaging as a mental occurrence and the thing imaged as an object. He is thinking of the distinction between the thing as it is and the thing as it appears, neither of which belongs to the subject. The distinction between subject and object, between the mind which thinks and remembers and has images on the one hand, and the objects thought about, remembered, or imaged — this distinction, so far as I can

*see, is wholly absent from his philosophy. Its absence
is his real debt to idealism; and a very unfortunate debt
it is. All these confusions are due to the initial confusion
of subject and object. The subject — a thought or an image
or a memory — is a present fact in me; the object may
be the law of gravitation or my friend Jones or the old
Campanile of Venice. The subject is mental and is here
and now. Therefore, if subject and object are one, the
object is mental and is here and now; my friend Jones,
though he believes himself to be in South America and
to exist on his own account, is really in my head and
exists in virtue of my thinking about him; St. Mark's
Campanile, in spite of its great size and the fact that
it ceased to exist ten years ago, still exists, and is to
be found complete inside me.*[26]

None of the writing in preceding pages allows you
to apprehend anything hard and fast. The viewer is
alienated when the subject of *Blow Job* has moments
of being neither engaged sexually nor acting in the
imaginary space of the filming set-up but being
'at a loss', running on empty. There's a sameness
that *forestalls the identification* of a real person or real
situation. During those non-identificatory moments,
he and you are in very close states of lull. This is
when the 'other' is not other as different but is other
as (the) same.

The theoretical, ideological and aesthetic ramifica-
tions of this proposed relation — of other as being
not different but the same — are a crucial difference
from usual thought. Sameness, not difference.[27]

None of the above *should* make *Blow Job* seem apprehensible or described adequately. The notion of adequateness means there is something that is possible to describe with language, something that can be made into a fetish object, objectified. The process of Warhol's film, *Blow Job* specifically, is simply not that. Thus the removal of the man to another 'mood' or mode, back to the blow job, or to touching his hair and bending his head sideways to the left, looking straight out, seeming to see something or someone for a flickering moment of recognition, then looking away or acting 'looking away' — all these can be continuances, without suddenly slipping into conventional representation or pseudo-documentary. That, for him, all this may be somehow a looking at a mirror — the constant removals via that series of self-identitites, uncomfortable self-mirrorings — is not just a 'possible interpretation' but an element of what is the real for us all in our identities.

Material Structures
In experimental film, pseudo-documentary would be, for example, when black leader is interjected between two scenes, taking the viewer out of the attempt to recognise a moment with respect to some 'known', or even to hold a moment; when the black leader interrupts, it is a material piece of time. If that piece of material time — perhaps five seconds of black leader between two shots — becomes the space, the emptiness made material, the interruption made physical (the movement of black leader on

screen still takes up time, and space), then that is not different in the order of representation from the preceding and following shots with their recognisable content. Better said, the black leader might even push the sequence into one of said pseudo-documentary truth, the black leader standing in *as if totally adequately* for something real, missing but apprehensible, imaginable, real.

But black leader can be used differently. It can be used problematically within a film, in a way comparably to Warhol's use of the countdown academy leader, the strip of film at the beginning of each screening that allows the projectionist to focus the projector. In many of his early films, Warhol left it in — not at the very beginning of the reel (with empty leader to follow) but immediately preceding the first frame of the first shot. It is thus within the film, creating uncertainty as to the reality and material of the beginning, and consequently the concept of beginning. This anti-narrative device, simple and economic as well as perceptually and formally exciting in its countdown structure of decreasing numbers, is a condensation of the kind of thinking that went into Warhol's early film work. With the countdown strip, the very idea of an anticipatory thrill, when film and the scopophilic experience is about to begin, coincides here with the technical, technicist outline of the constituent parts of film projection. It gives an anticipatory disease as to actual beginnings (and endings), destabilising and problem-atising the film, even before it is a film as such.

Black leader, which was used by other experimental film-makers with analogous Structural/Materialist thinking, highlights the uses to which a technical function can be put — to notions of seeing, truth, beauty, history and the questions of representation's meanings that art tackles. As such, it can be used dialectically within a film, as a technical function of film that is used for resonances beyond its surface structuring. The obverse is the case in Warhol's *The Chelsea Girls* (1966), where we are presented with a black screen for five minutes on one side — say, the left screen — whilst film is being loaded for the second screen, thus ensuring continuous projection on both. This means that the silent, unmoving darkened screen is indexical, standing for what it is — non-film. It is similar in effect to the areas of black in Warhol's early films, wherein it is not possible to decipher the depth or shallowness of the spaces, given the absence of figures that would establish scale; this lack of scale-reference moves you into a vision that isn't microscopic or macroscopic but, rather, unknown. It is not a stand-in for the unknown but projects the unknown materially.

The reduction of material — a concept and a concrete reality understood initially as a whole process — into a notion of crude material, the so-called substance itself, is caused by a metaphysics that is basically an idealism obliterated and then rethought. The 'cinematic apparatus' becomes the term for the whole operation — conception, acting, scale, lightness/darkness, linguistic use, referents,

signifiers and signifieds — every level of possibility that is deemed useful made into a concept. It is there that Warhol's influence as experimental film-maker is most evident. Such that, in *Empire* (1964) — Warhol's 8-hour silent film of the Empire State Building — the skyscraper can be both itself and an image of stabile structure and fragile evanescence. The effect is a Warholian 'this' which is inconceivable on some 'purely' film-critical, theoretical or academic level of concept; it is inconceivable that it function as if it were separable from the real of film. The split between those latter categories and Warhol's extraordinary films still astonishes. Repeating a loop, as he had done with *Sleep* (1963), wasn't just some mechanistic idea he had. *Sleep* exists also in a reconceptualised and recently discovered later version, where each frame is optically printed, one by one in the lab, and placed in reverse order so that the forward movement of time is constructed from its backward movement. Thus the terrible, post-Proustian tensions that the apprehensions of time bring, whether you are making a film or are theorising the universe's endlessness or end, whether you feel time pass on viewing a Rembrandt painting whilst you are standing there or should you not feel it pass in some commercial film (because the film is structured to obliterate it), whether Warhol's suicide painting's real stasis forces its 'opposite' — time's movement — upon you or not, everything becomes finally about time, because time is the only subject — time and death (and, some say, sex).

'You don't have sex with a name,' said Joe in
Kitchen, although you do, in fact, for the name is
that which names you, which makes you or which
signifies the you, inasmuch as any identity no
matter how artificial (is there anything else?)
is denominated.

The hesitations and unknowingnesses of Edie
Sedgwick in (the) *Kitchen* are mirrored by those
hesitations in the dark when the camera swivels
in *Harlot*. In *Kitchen*, there's the endless noise of
machines being turned on and people trying to
make themselves heard amidst the comings and
goings, people walking in front of the camera lens
(obliterating image), milkshake machines noisily
obliterating spoken language, only to be superseded
by the noise of washing machines, and so on.
In *Harlot*, the depth of space is unknowable at
the moment when the camera swivels; in the dark,
you cannot see, decipher, grasp. Unknowable at
that moment also is the direction that the camera
is going; will it show the off-screen gang watching
the filming, Warhol included? (As Callie Angell
has pointed out, on the soundtrack of *Harlot* you can
hear Warhol in the background giving instructions
to his actors.)[28] Or will it just swivel into unknow-
ingness, putting the viewer into a position of
having to make his/her own artifice, reflexively,
assuming that that is what is being done to get
from point A to point B. Whether back again is
another matter.

The Philosophy of Andy Warhol (1975) maintains:

I cannot fall apart as I was never together. / Sometimes people let the same problem make them miserable for years when they could just say 'So what'. That's one of my favourite things to say. 'So what.' 'My mother didn't love me. So what. My husband won't ball me. So what. I'm a success but I'm still alone. So what.' I don't know how I made it through all the years before I learned how to do that trick. It took a long time for me to learn it, but once you do, you never forget.[29]

In contradistinction to the previous sentiment, recall that the death series was divided into two parts:

The first one famous deaths and the second one people nobody had ever heard of: the girl who jumped off the Empire State Building, the women who ate poisoned tuna, the car crash victims. It's not that I feel sorry for them, it's just that people go by and it doesn't really matter to them that someone unknown was killed, so I thought it would be nice for these unknown people to be remembered by those who ordinarily wouldn't think of them. I still care about people but it would be much easier not to care. It's too hard to care.[30]

The non-decadence of Warhol's film strategies is clarified by the *use — the social real* — being made of these various realities of meaning(s), instead of their simply being passively consumable — a consummation that would make you the oppressed. It is that which Warhol's films *don't* situate you as.

Nor as the viewer in illusionistic control of the seen, or the scene either. To not make you either is the art of Warhol's work.

All this in the face of the running down and out of the temporal, a death-drive that (instead of being talked about, analysed, interpreted, then happily closured, 'Well, that passed the time,' and onto the next thing) we are cohabitors with. Warhol's audience's much-vaunted boredom: the given emptiness as opposed to the illusion of fullness, we have to deal with that emptiness somehow — with what is, what takes place and takes time.

Henry

The film that takes time to its ultimate is Warhol's *Henry Geldzahler*, in which Geldzahler smokes a cigar for 100 minutes, an endlessness of temporal continuity, but one ostensibly with an end in sight. The cigar will have been smoked — to paraphrase Beckett, 'this will have been another fucking happy day' — but precisely in the face of the cigar's apparent *telos*, the temporal anything-but-*telos* obtains time's movement unwinged, as he (Geldzahler) sits there, looks at you, looks away, touches himself, lies down, sits back up, lifts his thick-lensed glasses onto his forehead, puts them back on as he then *stares into the lens*.[31]

Geldzahler stares into, then away from, past, below, above, further forward than, short of, with focused eyes, blurry eyes, but always *vis-à-vis* the lens. And time won't stop, despite all of this movement, all

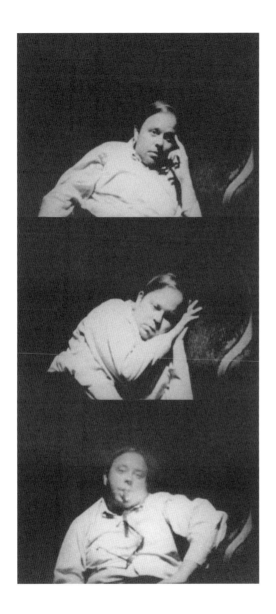

Stills from *Henry Geldzahler*
16mm black-and-white silent film,
100mins at 16fps, 1964
© 2008 The Andy Warhol Museum,
Pittsburgh, PA, a museum of Carnegie Institute

of these rearrangements of the body, of the sexualities of the man Geldzahler in the face of this filmic continuum, playing with his hair, moving it about, touching his at-moments pudgy face, setting up his visage to look serious, concentrate, then moments of letting go, giving up without *acting* 'giving up', just not doing, or doing less. The endlessness of the figure, the sexed figure in the face of time's relentlessness is revealed. At some point, two-thirds through viewing this 100-minute film 'of' Geldzahler, it is still the same shot set-up, same lighting, same relentless camera, the figure becomes — without taking form — skeletal. Whiter, more transparent, labile. The persona shown during the first 60 minutes now becomes detached. Though nothing has changed but time — the running down of time, the endlessness of time, materially making death viable, visible, material, metaphysical — it is not Henry anymore at all, a body hardly a body.

That kind of distantiation isn't some academic deconstruction, but rather a transmigration among subjects: from material to time, laid upon each other in a palimpsest. Once time becomes not an attribute but the subject/object itself, time and death become one. Obliterating time is to (seem to) obliterate death. Warhol's radicality in these films is to not do that.

In Warhol's silkscreen *Suicide* (1964), the jumping suicide figure is in repeated free-fall; the fall is in the material image's silkscreened representation of falling, whereas the figure is held, halfway to

the ground from the 200 feet up from whence it jumped. It is a time held, a time withheld, a suspension — not of disbelief — just suspension. That is another kind of death, time not having stopped. It has stopped in the terms of the image content — the camera-photo representation of a person held at that specific moment of a fall; but the state of *not* having stopped is contingent upon the continuum of the times alluded to in the painting being the *endless times* of repeated silkscreen images, seen as repetitions, on and on and on, different heights, variations of black paint applications (with the squeegee, through a screen) to make both the image and the process of image-making present. Making the time of perceiving that photo-silkscreen *be* our present.

Back to *Blow Job*: if two senses (sight and sound) can be relied upon to verify an orgasm, here, sound is absent. So the evaluation of the veracity of orgasm (undetectable, yet undeletable from our memory at the time of watching, with the history of its cinematic usages... the fake orgasm in narrative cinema — as opposed to the (faked) real orgasm) is always conducted via sight. For Warhol, the real is always a performance; this collusion is *in process* throughout the time of the film's projection.

We can thus never be — at last, in peace — consumers, finally succeeding in suspending our disbelief. The tension built by Warhol's camera set-up, *mise-en-scène*, editing structure, lighting and focus fills

whatever boredom is evoked. In Warhol's films, meaning is, in the end, always determined by production not consumption. And in the beginning too.

Equally, there is no verification or verifiability (within the film) as to which sex is having (the) sex unseen, so that the polymorphous perversity in Warhol becomes real, a polymorphous perversity merely literalised by Freud. Warhol's philosophical position towards *the real* is consistent via the processes engaged in this film: the real is (however unknown, not centrally visible or, as argued above, not audible) nonetheless existent as a horizon, an unknowable but assumable presence. It is assumed that the sex — which here occupies this presence — being had and being given is homosexual sex. But the social realities that lead to this, via extra-filmic knowledge or assumption, are one thing; the material process at hand, another. Even the title, *Blow Job*, ought not *qua* title be somehow digested as unquestioned truth. Homology of title and artwork is just another assumption. All this to say that Warhol's real is a real like no other representational real and is located precisely in such ambiguities and ambivalences and polymorphisms — and it is not so much that most other representations in existence are of a different order, it is just that the vast cultural *imperium* is predicated upon suppression, repression and denial of them.

The tension of polymorphous perversity — when enacted and when part of a circuit from which the

viewer cannot absent him or herself — is one to be sought devoutly. Other than that, representation becomes nothing but a fetishised consumption of the already recognised. The death-drive inherent in that (which is exactly its illusionist suppression) is what is at issue. The pleasure beyond gender or sexuality — breaking a taboo in its most radical form to allow pleasure as such — is the definition of the polymorphous perverse and its effects. Sex therein is detached from identities, the identities ideologically maintained for supposed satisfactory coupling. Is it necessary to take on identity in the first place for sexual pleasure? In *Blow Job*, the eroticisation, its constant re-beginning, is apart from (not a part of) identity — or, at least, not collapsed into it. The viewer's conscious expectation that it should be homosexual sex could be at odds with his or her unconscious pleasure in looking/being looked at and any spontaneous identification with the subject. It is now *you* looking back at a scene. So you can indulge in the seeing/being seen eroticisation via a polymorphous non-homosexual non-heterosexual *sex in (this) process*.

That is truly a radical revision of sexual pleasure; for the viewer, watching — no less if 'only' through the satisfactions of scopophilia — is part of that process, without engaging in physical sex at that moment. The representational nexus is outside of the given ideological gender-identity positions that are the social strait-jacket we're given, at such cost.

The question remains: how much is belief in gender's role needed for a breaking away from it, and for the attendant excitement of that? Is it an obliteration, thus, of gendered sexuality, or is it a reification of such, precisely in its transgression? The difficulty for artworks is to make the breaking of the strait-jacket not a transgression, not *jouissance*, not 'against' some pre-given convention (whether homosexual or heterosexual), but rather the obtaining of pleasure of a different sort. That is the impulse of such a work as this. What a work is this.

The Concept of Marcel Duchamp

In Marcel Duchamp's *The Large Glass*, the screen, the glass, is divided horizontally, which is, however semi-consciously, echoed by Warhol's figural place-ments in *Harlot*, particularly the band of light along the top edge of the horizontally placed couch at the Factory. The so-called coffee grinder in the Duchamp is 'replaced by' the women on the couch in the film or the cat escaping off-screen and returning. In addition, Philip Fagan centred above the top edge of the couch, bending down and over, brings to mind the *Glass*'s spiral descending from upper right to middle lower left, in near-Wölfflinian *Klassische Kunst* Mother-of-God triads. At the turn of the last century, Wölfflin read Renaissance art as being structured on 'holy family' triangles, from a strong horizontal base rising to the heavens. Warhol's art historicism here is not some insider reference; rather, it is a matter of this real world as informed by the aesthetic. With Warhol, there is a politicisation of

the aesthetic, a socialisation of the aesthetic, instead of its being (as with so many others in the filmic avant-garde of the 1960s, and since) aestheticised politics, the social made aesthetic.

Taking Duchamp's image apart, we're left with the incest taboo. Duchamp's sister, brother/sister as sisters, cup-like triangles (standard stoppages, he called them) descending, nude. Heaven to earth, above couch, beneath couch, BC and AD. The tensions in Warhol's Catholic universe are interestingly far more tense than those in Duchamp's; whatever you say about the Duchamp, tense it's not, deconstructed it supposedly is, perceptual it wants to be.[32] With Warhol, tense it is, deconstructed it supposedly isn't, perceptual it certainly is. The two intellectual, aesthetic art universes are intertwined inexorably, with Warhol taking the *concepts* of the Duchampian into the realm of the perceptual real. Whereas for Duchamp, 'It is the concept that wants to put [the perception of] fifty Campbell's soup cans on a canvas that interests us.'[33]

End of Self
In *Blow Job*, the looking down — ostensibly at the third person in the circuit, the giver of the blow job — is a long, slow looking, as if there's a point of reference for rest. The head stays that way for a good 15 seconds, many times during this film. It is in those moments that the greatest stillness is given by the film.

Only the scratches and dirt particles — white (if on the negative), black (if on the film being screened) — betray time's continuum, when the man is unmoving, completely still, mostly in the dark, the chiaroscuro lighting muted, his head turned slightly askew and to the left. What motion there is, that of the unseen participant, is other than the motion of the materiality of film itself; motion is inferred, off-screen. After which, the sudden upward jutting of the subject's head all the way back, as if possibly *almost* in ecstasy (which is, in this film, more common than representations of ecstasy — though 'almost in ecstasy' is itself a representation of ecstasy). This is followed by the head coming back down halfway. The actor's eyes remain closed when his head comes down — they remain closed more often than not — and he is viewed without looking back at you. Such an anticipatory moment lived with eyes closed makes him all the more impenetrable to us, impenetrable to any kind of inference into the panoply of possible expressions of emotion. That panoply of expression becomes reduced — once he opens his eyes finally again — to staring out at the audience, at times with unseeing eyes.

Waiting, eyes closed again. Stillness. And again in this stillness is the evidence of time's passage, via the movement of filmic material through the projection gate, the vertical scratches from the film's deterioration manifest throughout. There is no stillness there.

At the 'end' of one 'sequence', the actor seems to be uttering a word, as if against his will and no doubt against the directorial request that he not speak, a directive that is inferable also in the portraits of *The Thirteen Most Beautiful Women* (1964—1965), *The Thirteen Most Beautiful Boys* (1964—1966) and the *Screen Tests* (1964—66) film portraits. As with these other examples, a rule is broken. So his half-uttered word is no sooner spoken than unspoken, back to silence, as if the actor had, without will, lapsed into speech. With all the setting up, the mechanism, the people there whilst filming, the self-conscious apparatus in all its forms producing the artwork, *it is still possible for the subject to be somewhere else*, inside himself, forgetting the admonition not to speak, then relapsing into the structure and directorial system to be adhered to. There is an uncanny identificatory moment for the viewer in all this, as if one is in the moment of one's own — however elusive — caught out into another world: each moment-to-moment change immediately undermined by another system's intrusions, whether it's the social that intervenes or light that obliterates shadow (as opposed to producing it). Or darkness envelops the scene; the film spots that form the word 'Kodak' on the 16mm acetate, here projected vertically, are seen flashing by, letter by letter — signifying possible sexual gratification's 'ending', as the film reel is running out. What then also must end is the viewing of the act till the next reel, the ending of this segment's viewing being consonant with the ending of possible identifications for the

viewer, and so on. Then the next reel begins, first black leader then, some seconds later, the inevitable light spots, as the image of the man flares into view — the flare-ins or flare-outs caused by light getting onto the film when reloading the camera. Warhol's set-up is such that however real something may seem for a moment, that moment is truly no more — ever — than that; some moments distended more than others are but moments still.

It is thus, then, that this film process works against any suspension of disbelief, any — however barely — successful identification; it situates itself in the endlessness of temporal continuum, without respite via imaginary identification(s) by the audience, without the satisfaction of imaginary narrative or imaginary psychological completion of an act, a thought, an image, whether narrative or not. Or, if it does touch on any of these things, then it is never for more than a moment. Yet in those moments, there is no sign of respite. There is the actor's perpetual need to find a position, whether head back, or sideways, or to the front down right, or looking, or avoiding looking. Set against (and, with possible sexual excitement, coming closer or less close to) orgasm, these contingencies play out for 36 minutes against each other. A constant *resettling of the self*, say staring sideways, or downward, or resting the back of his head on his leather jacket collar — with or without causation by increased or diminished sexual excitation. The actor throughout is always unsettled, not in place, like an actor on stage not knowing how

to just stand and do nothing and still emanate
belonging to that moment's position. A replacing
of self, then relinquishing a position imbibed for
another, and on and on. This gives the viewer of
this series of resituatings no believably true moment
in which to allow identification into the scene
(let alone into any imagined narrative) to take
place, or even into the 'person' or 'actor' or 'character'.
The subject/object is never subject/object long
enough to be accepted into a structure of the imagined
real, that which would allow identity to be assumed
and then identified into. Or rather, not never, but
only so rarely — moments only — making those
moments for the viewer as fragmentary as they
are for the man filmed for *Blow Job*.

1
Quoted in Christie's auction catalogue *Post-war & Contemporary Art*,
New York, 16 May 2007, p.100.

2
Samuel Beckett, *Lessness*, London: Calder & Boyers, 1970, p.15.

3
Andy Warhol's New York studio from 1963 to 1968 (his later studios
were known as The Factory as well).

4
Silent speed is when a film is run at either 16 or 18 frames per second
(depending on the projector), as opposed to normal speed (24 fps), at which
speed most 16mm films are shot.

5
The records of the New York Film-maker's Co-op show that Warhol was
paid around $30. Gregory Battcock's 1965 essay 'Notes on *Blow Job*' in *Film
Culture*, the first on this film, meant that there was a context for the work,
however small it might have been; *Blow Job* didn't exist in a vacuum. See
Film Culture no.37, Summer 1965, pp.20 — 21. 'Notes on *Blow Job*' was later
republished as 'Humanism and Reality — Thek and Warhol' in G. Battcock,
The New Art, New York: EP Dutton, 1966, pp.235 — 42.

6
We were on a Dutch ship called the SS Maasdam, which carried passengers
(mainly students) over to Europe at low prices. Each trip also took along
five professors or lecturers from universities — or writers or artists of
some note — to give daily lectures or seminars, for which they got free
travel. Battcock and I hit it off immediately. His taste was not limited
to Warhol: on board, he also lectured on the sculpture of Bellini. Battcock's
political aesthetics were also evident in his active work within the Art
Workers Coalition (AWC), which tried to give artists a voice, alongside the
curators who ran the museums and exhibited their work; the focus of his
ire was the Whitney Museum of American Art — with its souvenir store
replete with sculptural *tchatchkes* — along with the Museum of Modern
Art and the Guggenheim, amongst others. In 1970, the AWC organised a
boycott of MoMA, armed with a famous poster 'Q. And Babies? A. And Babies.'
that depicted the aftermath of the American Mai Lai massacre in Vietnam.
The AWC saw the museum and its house curators as politically reactionary.
The resistance was vocal for a while, then it fell into the silence that,
by now, almost forty years later, is deafening.

7
I was already aware of the radicality of Warhol's art, specifically through
having found the double car crash silkscreen painting *Saturday Disaster*
(1963) to be a ground-breaking and powerful work.

8
Warhol's exaggerated feyness was both an affectation and real, which is
a lesson both about being and about being what one wants to be, and that
the former and the latter need not be at odds. Whenever I came into contact
with him, I found that a simple sentence, or question, got transmuted
into an aesthetic, a social interaction and a performance. Conversations
ran like: 'Gee, Peter, where'd you get all those rings... What's that one, oh,
oh really, and that one? God you have so many, oh and on that hand, what
is that one...' This was about a relatively modest four or five rings, three
on one finger of the left hand, the other two on the right hand. It was such
a pleasure to be around Warhol briefly every year or two for nearly twenty
years, and there wasn't a week without some thought of him or his work.

9
This regard makes the 'you' present in your absence, however invisible
the spectator is physically.

10
See Bertolt Brecht, 'Über den Realismus' (1937−41), *Gesammelte Werke*,
Frankfurt: Suhrkamp, 1968, p.361.

11
This is not to forget an absence, the unseen fellator (if such), about whom
— from the evidence of the film, at least — we can know nothing.

12
The Freudian mode of looking at a film comes up via the term fugitive.
Anecdotally, I wrote a catalogue essay entitled 'Fugitive Theses re: Thérèse
Oulton's Paintings' (in *Fools' Gold*, London: Gimpel Fils, 1984) and it was
pointed out to me by the literary scholar Angela Moorjani some months
later that the words 'theses re' incorporated an anagram of Thérèse —
noticably not a particularly hidden one, yet one which remained in the
unconscious, for whatever reasons, its repetition being its libidinal force.

13
Stephen Heath discusses this construction of the subject as falsely
unified. His examples elucidate the impossibility of supplanting 'mind'
for 'body': 'Thus if we had, say, (1) "I am thinking about God the Father,"
(2) "I watched a movie yesterday," (3) "I was hit by a cricket ball," (4)
"I'm meeting Peter Gidal for doughnuts in the park," I should be able in
each case to bring the "I" back to my enduring substance. We aren't told
what the latter is, but it seems not unfair to try "my body" as a reasonable
candidate and see how we get on making that the identity of the "I".
Fine for (3), not too good for (2) and (4) (just "my body watched a movie
yesterday," "my body is meeting PG in the park"?), even worse for (1)
("my body is thinking about God the Father"?).' Stephen Heath, 'Le Père
Noël', *October*, Fall 1983, vol.26, p.46.

14
For many, the Wölfflinian history of classic art ought to be the model for a structural breakdown of a works constituents without falling for composition or form for its own sake. See more in *Die Klassische Kunst*, Munich: Verlagsanstalt F. Bruckmann, 1904.

15
In a 1971 text on Warhol, I used the term 'hand-touch sensibility' for Warhol's silkscreens — then five years later, as a determined Materialist (of one kind), I stated that the crucial element of the silkscreens was not this hand-touch sensibility, with its implications of humanism, but rather a material process of paper, ink, hand and eye. In a similar way, at the same time (in the early 1970s), the term 'integrity' — as in the integrity of colour and form — was meant not as a moral but as a non-normative term. The term 'sensibility' demonstrates a similar problem, of masquerading, like integrity, as a moral category. See Peter Gidal, *Andy Warhol: Films and Paintings*, London: Studio Vista, New York: Dutton, 1971; Tokyo: Parco, 1978.

16
Conversation with Callie Angell, New York, November 2006.

17
S. Beckett, 'Ooftish' (1938), *Collected Poems in English and French*, London: John Calder, 1977, p.31.

18
The concept of the satisfactory is always a normative concept, whereas 'integral' must be understood to not mean a moral good (or a whole completion, with its ideological meanings), but simply a technical function.

19
Mary Douglas's *Rules and Meanings* (her 1973 anthology on anthropology and time) quoted a page from my then-unpublished book *Andy Warhol: Films and Paintings* (a segment of which had been published in *Films and Filming*). It appeared alongside chapters by Wittgenstein, Husserl and Schopenhauer on the presence of time and its running down and out towards death. The problematics of the presence of time as a concept and a concrete reality was as difficult to deal with in the 'now' of the 70s as it was a hundred years earlier. See Mary Douglas, *Rules and Meanings: The Anthropology of Everyday Knowledge*, Harmondsworth: Penguin Books, 1973.

20
'The unknown, choosing its weapons from the hoard of values, is also the unknowable.' S. Beckett, *Proust*, London: Chatto & Windus (Dolphin Books), 1931, p.56.

21
Derrida's critique of presence notwithstanding — a critique that is anything but lacking in tedious self-presence.

22
Stephen Heath, 'Repetition Time: Notes Around Structural/Materialist Film' (1978), *Questions of Cinema*, London: Macmillan, New York: St Martin's Press, 1981, pp.165—75.

23
When we are *in* the temporal, we are within that passage which is towards, and always thus in the presence of, death. But *loss* is not death, as when time is recovered death is as well. See S. Beckett, *Proust, op. cit.*

24
Parenthetically, Lacan said condensation is the superimposition of signifiers. See Jacques Lacan, *The Four Fundamental Concepts of Psycho-Analysis* (trans. Alan Sheridan), New York: WW Norton, 1981.

25
Heidegger and Nietzsche, who equally confused personal and social personas, likewise offered a 'so what' in other forms in their philosophies that are also anything but decadent. In his 1926 *Being and Time*, Heidegger writes: 'The complete irrelevance which exudes from the nothing and nowhere, means not absence from the world but rather bespeaks of the innerworldly. Being as such as so completely issueless that solely the world in all its worldliness inveigles itself on the grounding of this inner-worldly irrelevance.' ('*Die völlige Unbedeutsamkeit, die sich im Nichts und Nirgends bekundet, bedeutet nicht Weltabwesenheit, sondern besagt, dass das innerweltlich Seiende an ihm selbst so völlig belanglos ist, dass auf dem Grunde dieser Unbedeutsamkeit des Innerweltlichen die Welt in ihrer Weltlichkeit sich einzig noch aufdrängt.*' Martin Heidegger, *Sein und Zeit* (1926), Tübingen: Max Niemeyer, 1993, p.187, author's translation.) In 1911, similarly, Nietzsche wrote: 'I read [my last text] the day before yesterday with deep astonishment, and as if it was something new.' (*Ich habe sie vorgestern mit tiefem erstaunen und wie etwas neues gelesen.* Friedrich Nietzsche, *Sämtliche Werke* (Summer 1880), vol.9, Munich/New York: Deutscher Taschenbuch Verlag & de Gruyter, 1980, p.213, author's translation.) Nietzsche's reading of his work as if it were not by him — a moment of unrecognition — places the subject in a process of unknowing and a state of not yet being found. My argument in this book on *Blow Job* is not one that will disinter the social from the production of the artwork. But it is one that places the artwork into that social. The social is that which determinately does not give itself as immediately recognisably that!

26
Bertrand Russell, *The Philosophy of Bergson*, Cambridge: Bowes & Bowes, 1914, pp.23—4. At the time of Russell's writing this, a replica of the Campanile had just been built (1912) — the one standing today — after the complete collapse of the original one in 1902.

27
Against sexual identity would be, then, neither difference, *'woman-as-other' against a (male) norm, outside language and power, nor* homogeneity, *'woman-as-same', assimilating the male role in patriarchy, identifying with it. Such a role would deny both women's subjective and objective histories, ideologies and powers. Such a conceptualisation is both descriptive and prescriptive, through its reproduction in language of that set of meanings and politics. The lack of representation of the male and female body, let alone any narratives and narrativisations that are motored by such, means unpleasure. Thus a different kind of (un)pleasure is instantiated by such cinematic practices. The representation of the male and female, and the situating of the male and female viewer in representation, and the depiction of male and female sexuality (whatever that is) is the ideological mode of reproducing dominant relations, no matter what the 'actual' narrative ostensibly is. Because the seen, and the scene, that we rewitness, is the reproduction of positions of secure perception as to the sexualised body, that body as always the* other *against which the sexual identity of the 'I' is reproduced in the interests of patriarchal relations as much as for the reproduction of labour power necessary for capitalist relations, [...] natural, pre-given, pre-given as natural.,* Peter Gidal, 'Against Sexual Representation in Film', *Screen*, vol.25, no.6, 1984, p.27.

Add to which, in 'Problems in Current Theory', Jacqueline Rose wrote: *This raises the whole question of the 'relative potency' of images as indicated by Peter Gidal's films and his accounts of their practice: the avoidance of the socially coded objects of fetishism, the refusal (after 1972 when articulated) to use images of women (or men) in his films: with the — symptomatic — duality that this then imposes in the theory: against anthropomorphic identification through the narrative relations of human figures and also, the inevitable stressed addition to the general rule, against images of women, specifically, in particular, in or out of conventional narrative [...] At one level this position is clear, if pessimistic: the objects to be subjected to the film process should not be the culturally received objects of fetishism and censor.* Teresa De Lauretis and Stephen Heath (eds.), *The Cinematic Apparatus*, London: Macmillan, 1980, p.180.

28
Conversation with C. Angell, *op. cit.*

29
Andy Warhol, *The Philosophy of Andy Warhol (from A to B and Back Again)*, New York: Harcourt Brace Jovanovich, 1975, p.112.

30
'Warhol's Death and Disaster' in *Andy Warhol's Green Car Crash*, Christie's auction catalogue *Post-war & Contemporary Art*, New York, 16 May 2007, p.49, quoted from P. Gidal, *Andy Warhol: Films and Paintings*, London/NY: Da Capo Press, 1991, p.38.

31
The Beckett quotation comes from a scrawl found in reply to some questions about light and dark in *Krapp's Last Tape*, in James Knowlson's private papers, now held in the Reading University Beckett Archive.

Re. staring into the lens: André Kértèsz in 1981 took a photo of me in Hyde Park near the Serpentine Gallery by an oak tree saying 'Peter, look straight into the lens, you are looking at your father.' In the final printed photograph, the photographer who was always technically in control therefore conscious — even though it was just an instant — had the bark of the tree, the branches, the surface, in incredibly hyper-sharp focus, with me looking into the camera from just slightly to the left and ever so slightly out of focus, though all from the ostensibly same plane. So a portrait can become an artifice whilst being a document, via the lens. And a narcissistic recollection can also inform an aesthetic and technical insight *a posteriori*.

32
Duchamp alleged that his work enacted an 'anti-retinal' turn, and his notes on *The Large Glass* were intended as a corrective. However, *The Large Glass* (as well as another piece, *The Illuminating Gas* (1947), which was to be looked at with one eye open, to be stared at voyeuristically in secret though a hole in the door) is nothing if not retinal. The notes for *The Large Glass*, entitled *Green Box*, were to be consulted when seeing it 'because, as I see it, it must not be "looked at" in the aesthetic sense of the word. One must consult the book and see the two together. The conjunction of the two things entirely removes the retinal aspect that I don't like.' Duchamp quoted in Pierre Cabanne, *Dialogues with Marcel Duchamp* (trans. Ron Padgett), New York: Viking, 1971, p.42. The work functions as a point of contradiction, which arises from the desire to annihilate the retinal, as with any desire to obliterate one aspect of one's libidinous subjectivity. That's what makes art, after all.

33
Duchamp quoted by Samuel Adams Green in *Andy Warhol, A Retrospective* (exh. cat.), Philadephia: Institute of Contemporary Art, University of Pennsylvania, 1965, p.6.